# PAINTING FOR THE LEISURE YEARS

## The Creative Years

MARGE TUTHILL

Paulist Press New York, N.Y. and Ramsey, N.J.

Library of Congress
Catalog Card Number:   79–56621

ISBN:   0-8091-2223-5

Published by Paulist Press
Editorial Office: 1865 Broadway, New York, N.Y. 10023
Business Office: 545 Island Road, Ramsey, N.J. 07446

Printed and bound in the
United States of America

In Memory of
Harry H. Tuthill
1885–1975
and
Julia Maney Tuthill
1887–1973
my parents who shared with me
the depth and wonder
of their creative years

## Acknowledgments

This book could not exist without the sharing of those at the Turner House in Greenport, N. Y. and Colonial Village in Southold, N. Y. I am also indebted to the following people for taking the time to read the manuscript and for offering numerous helpful suggestions: Pat Megale, Dot Carey, Maria Harris, Tom Lowry, Marjorie Meyer and Delia Lynch. Jean Marie Hiesberger, my editor, offered the patience, kindness and expertise that both the manuscript and the author needed.

# CONTENTS

*PREFACE*  1

*INTRODUCTION: The Creative Years*  3

1  **ACRYLICS:** *The Modern Versatile Medium*  7

2  **HELP IN GETTING STARTED**  11

3  **NEEDED MATERIALS:** *Care and Use*  15

4  **COLOR**  27

5  **MAKING A PAINTING**  37

6  **SKETCHING AND DRAWING**  45

7  **SUBJECT CLUES**  61

8  **COMPOSITION AND DESIGN**  83

9  **PAINTING STYLES**  93

10  **FRAME AND SHOW**  103

11  **OTHER USES OF ACRYLICS**  107

12  **OVERCOMING HANDICAPS**  109

**GLOSSARY**  113

# PREFACE

As an art teacher for over twenty years, I have worked with many beginning painters. Over the years, I have searched for ways to help others learn technique, develop their own special creativity and enjoy the process. In this book, I have compiled the best of what I have discovered in the hope of offering a simple, concise guide for beginning painters.

Recent teaching experiences have made me aware of the fact that some of the most creative beginning painters are men and women over sixty and many who must deal with physical handicaps. I have directed portions of this book to their special needs. The book is printed in a large, bold type for those with eye problems. I hope that many beginning painters will find helpful suggestions in this book.

# INTRODUCTION

**The Creative Years**

Painting is a many-splendored activity. It's fun, yet it's work. It's relaxing, yet it's also challenging. It involves activity and also contemplation. Painting is the use of materials, but it produces a creativity that can be spiritual. Painting has all these opposite possibilities which can be understood only through experience.

Painters search, observe and express their art in many ways, using marks and hues. The nature and quality of their expression are limited only by their insight. It is an effort to see, hear and feel with deep, inner integrity. It's maturity, a sign of the creative years.

In the creative years people possess a sense of depth and wonder. It is painful to adapt to the changes in one's life. Aging, retirement, illness and disabilities, loss of com-

panions, and failures are all challenges that require change and adaptation. However, these very changes can help the individual to appreciate his or her own uniqueness, and to seek new ways of living. The individual learns not to rely upon that which is material, physical or oriented from the outside. Acceptance is necessary and growth is possible. The creative years are a time of growth and wonder. Creativity can blossom!

Creativity is a part of every person. It is most visible to us in children. The very young, unconcerned with outside pressures, sparkle with an innocent creativity that is delightful. As the child is trained and taught, he or she often abandons this creativity in an effort to meet the demands of the outside, grown-up world. Too often, the goals become imitation and conformity.

Artists strive for creativity combined with a deep understanding of life. This kind of understanding is beyond the creative child and very difficult for the artist because it requires the maturity that usually develops from age and experience. The mature person, who makes the most of his or her creative years, needs only tools and techniques to become a painter in the best sense of the word.

The biggest stumbling block to any adult considering painting is probably a fear of drawing. Most of us have said, at one time or another, "I cannot draw a straight line." This feeling about drawing is often the result of

rigid "so-called" art courses taken in schools. Drawing and the skills involved in painting can be learned and it is often easiest for those who have had little training in the subject to learn, for they have the least to unlearn. With time and effort, the drawing and painting skills necessary for the painter can be learned by anyone who can master arithmetic, sewing, or driving a car. Basic drawing and art information are included in this book for study and reference.

There is no typical "mature painter." In fact, adults in the creative years, making use of their individual possibilities, find their own unique styles. Some mature individuals turn to paint-by-number paintings that offer no chance for creativity and strain the eyesight. This is unfortunate. Number paintings are coloring books for adults; they only control, limit and demand. They offer little real satisfaction when compared to the satisfaction of having done a painting from scratch.

Adult painters, particularly the elderly, frequently feel they are going to be limited to a Grandma Moses-type style. Grandma Moses began painting as an elderly woman, using a primitive style that is somewhat childlike. However, her work is not childlike in its organization and in the highly detailed story and lifestyle she depicts. She tells a mature, wise story in her own creative way. Grandma Moses is a painter to be admired, but the style is

hers; it is not the style of late beginners. Style and subject matter need to spring from within the painter if the result is to be art.

Mature beginners must deal frequently with the loss of physical dexterity and stamina that can set limitations on activities and demand compensation. These problems do not rule out the ability to paint. Painting remains a possibility long after a person may have to give up activities such as sports, reading, stamp collecting, needlework and other hobbies. In Chapter 12 you will find some specific ways to overcome and compensate for handicaps that might make painting difficult. Readers with handicaps and limitations will be able to add their own lived out know-how to the ideas presented. Physical problems can actually bring about opportunities for contemplation and solitude that nurture the creative life. The possibilities of painting might well become greater than ever before.

Mature adults who want to paint usually need guidance in the beginning. This book is intended to be a guide. Its purpose is to help in opening new doors.

# ACRYLICS:
# The Modern Versatile Medium

Acrylics are more versatile and convenient to use than oil paint and watercolors, yet they can offer results similar to these traditional mediums. All three forms are popular with artists. To point out the advantages of acrylics, it might be helpful to describe oils and watercolors first.

*Traditional Mediums*

## Oils

Oil paints dry slowly and most of the colors are opaque. The paints are applied to canvas or other sturdy surfaces that have been prepared with a white ground called gesso. Oils must be mixed with turpentine and/or linseed oil and can then be applied thinly or thickly using a brush or

painting knife. Good quality oils generally retain their color permanently. However, mixed colors can sometimes change color when exposed to bright light and/or with time. A thoroughly dried coat of oil paint can be painted over provided the artist uses thinner layers of paint. The drying time for an oil painting varies and is dependent upon the thickness of the paint and weather conditions. Some paintings take weeks to dry. Both the paints and their mixing mediums have an odor.

## Watercolors

Water colors are transparent and dry quickly. The artist mixes the paint with water. Specially prepared rough paper is the best surface for water colors. It's difficult to rework painted areas. Consequently, the painter must understand the medium and carefully plan ahead. A skilled and knowledgeable artist can achieve many unusual effects with watercolors. Good results are very dependent upon the use of special techniques.

*The Modern, Versatile Medium*

## Acrylics

Acrylics offer numerous advantages over traditional mediums. This relatively new medium was developed as a result of trends toward modern art. Modern artists, search-

ing for new ways of painting expression, required new and more versatile paints. As a result, researchers produced acrylic polymer paints. The earliest versions had defects that have been corrected or minimized in current products. These paints give beginners and professionals new freedom to explore. Since it's not necessary to know much about this medium to get results, beginning painters are spared many of the technical problems encountered when using oils and watercolors.

Unlike oils, acrylics are quick drying and use water as a mixing medium. Once dry, the colors are permanent and the paint is waterproof. The paint has a good consistency and is easy to mix and control with a brush. Because the colors are opaque it's possible to quickly cover over a painted area. Even white can completely cover a dark or bright color. Acrylics have no noticeable odor and are therefore good to use indoors. They can be successfully applied to almost any non-oily surface.

Most well-known paint companies produce a quality line of acrylics. Among the best brands are Grumbacher Hyplars and Liquitex. Poor quality paints are a waste of money. When purchasing acrylics it's essential to seek advice from an experienced artist or a reputable art supplier.

Acrylics are versatile and can be used like oils or watercolors. For watercolor effects, the paint is thinned with water and applied using watercolor techniques. When applied thickly with a brush or painting knife, acrylics can

produce the effect of oils. The main difference between acrylics and oils is that acrylics dry much more quickly.

In this text I will share with you my own method of using acrylics in a manner similar to oils. The method I outline is somewhat simpler than that found in texts on acrylic painting, but it is one that I have used and found very satisfying over the last two years. The method has been successfully shared with many students, ranging in age from 7 to 87.

My experiences as both painter and teacher have led me to believe that acrylic is an ideal medium for beginning painters. Beyond paints and brushes, few accessories are necessary.

# HELP IN GETTING STARTED

Painting is a delightful experience, but getting started can seem to be something slightly less than delightful. A beginner can find the process of painting confusing, difficult, and even overwhelming. Such reactions are perfectly normal. Many artists struggle with "getting-started tensions" each time they begin a new painting. For beginners and pros, these feelings are usually temporary and they can even enhance the painting experience. Initial attempts to paint will be easier if you seek help from books, including this one, and/or find the right kind of teacher.

There is a great deal to learn about painting. In the beginning, you need help with everything from searching for your own style to selecting and using painting materials. There is danger, however, in being taught too much.

Help, whether from a book or a teacher, should offer support, encouragement and information without limiting the person or forcing him or her toward outside goals. It's by experimenting, exploring, and discovering, that the person experiences real growth as a creative painter.

The beginner who chooses or is led to emulate what has been done by others can lose the essential beauty of the painting experience. Some "how-to" books and some teachers are apt to encourage duplication of existing artworks. By implying that the beginner can reach the goal of the master in only one prescribed way, these "authorities" discourage the beginning painter from developing his or her individual creative powers. Sources of help which impose a style, encourage copying, or set up rigid approaches to art should be avoided as well as the teacher who is eager to touch up a work. Teacher-touched paintings automatically take away feelings of creativity and satisfaction.

Beginning painters need gradual exposure to fundamental technical information and creative attitudes. The best help often comes from the teacher who is more educator than painter, and from reference books rather than step-by-step "how-to" manuals. PAINTING FOR THE LEISURE YEARS seeks to assist beginners directly and help them to find other appropriate assistance.

Finding the proper book or teacher begins with a search. Books are available in art shops, libraries, muse-

ums and general book stores. Take the time to glance over the contents and choose selectively. There are a number of good magazines available. One recommended magazine is *American Artist* (One Astor Plaza, New York, NY 10036, monthly, $17 a year).

Locating a teacher may require effort. Art shops and museums often have information about local teachers who offer classes. Adult education programs frequently have good painting courses. Workshops are sponsored by many churches, senior citizens' groups, and home bureaus. Check your local yellow pages and the newspapers. The grapevine is also a source.

Once you have the name of a teacher you can learn something about the quality of his or her teaching by questioning both the teacher and some students. Ask especially about teaching methods. Eventually, however, the only way to judge wisely is to attend a few classes. Then a decision can be made on first-hand knowledge.

Although painting is an "on your own" activity, joining an informal painting group has value. The communal aspect of such groups is particularly helpful for beginners. Painting with others offers opportunities for discussion, sharing and comparing. You can learn a lot and have fun too! Like skiers, fishermen, and others involved in "on their own" activities, painters usually form enthusiastic groups.

Criticism from others, whether family, friends, artists,

or those passing by, can be helpful to any painter, but is especially useful for the beginner. However, it must be evaluated by the painter. I frequently rely on the views of several non-painting friends. Their criticisms always seem to include suggestions on ways to improve my work. I consider the criticism to decide on its validity, but I find my own solutions. My friends do a much better job of seeing what is wrong with my paintings than I do. Their solutions are not always the ones I would choose. Without their criticism, I would find it difficult to improve my paintings. The creative painter learns to evaluate and use criticism to his or her advantage.

The value of criticism is determined, in part, by the artist's ability to accept and analyze it. While it is difficult to accept criticism, the critic may be helpful. It is wise not to get upset or act too quickly. Instead, evaluate; accept or reject what is said on the basis of what will help you to improve your painting.

The beginning painter is wise to accept help from any source provided the assistance offered is in accord with his or her own feelings, freedom and creativity. Help must offer guidance rather than control. The best assistance is open, informed, honest, and seeks to encourage creativity in every way possible. Seek this kind of help if you want to enjoy painting.

# NEEDED MATERIALS:
## Care and Use

A minimum amount of quality materials is needed by beginning painters. The basic supplies and their current costs are given below.

**The Painter's Supply List**
*(Note: prices quoted are from 1979 sources.)*

**Sketching Materials:**
   Pens and Pencils (average cost under $1)
   Paper, Sketch Pad or Sketchbook (prices vary with
      size, number of pages, and the quality of paper—
      (average cost under $1)
   Eraser (average cost under $1)

**Acrylic Paints** (2 ounce metal tubes):
White
Cadmium Red (or Grumbacher Red)
Cadmium Orange (or Hansa Orange)
Cadmium Yellow (or Hansa Yellow)
Yellow Ochre
Chromium Oxide Green
Manganese Blue and/or Cobalt Blue

*Cost: Prices range from $1.25 to $3.50 per tube. The price is
determined by the paint ingredients. Cadmium colors have
excellent quality, but are the most expensive. Less expensive,
and still good substitutes are listed in parentheses. The
initial set of paints will cost approximately $10 to $15.*

**Brushes:**
2 to 4 Nylon Flat Brushes, #2, #4, #6 and/or #8
1 or more thin Pointed Nylon Brushes or Red Sable
Brushes #1 or #2

*Cost: Prices range from $1 up depending upon the quality and
size.*

**Canvas Panels and Other Painting Surfaces** (12 × 16
and larger—prices listed are for 12 x 16 size):
Canvas Panel (75¢) or
Stretched Canvas ($3) or

Canvas Paper Pads (10 sheets for $3.25) or
One of the other painting surfaces mentioned in this
  chapter *(most cost less than the above)*

**Palette:** *(Note: wax paper and cardboard palettes can be made
without cost.)*
Disposable Paper Palette Pads ($1 to $3)
Ready-made Palettes ($2 and up)

**Easel:** *(Note: This is not an essential item for beginners.)*
Table Easel (average cost $5 and up)
Standing Easel (more expensive and must be sturdy to
  be useful—prices for a good one range from $20 up)
Water and Container for Water
Paint Rags or Paper Toweling

## Sketching Materials

A sketchbook is a valuable tool and reference notebook.
Sketch pads and scrap paper can also be used. Any soft or
medium charcoal pencil or felt tip pen is suitable for
sketching. The choice is a matter of personal preference, as
is the choice of an eraser.

## Paints

For a full discussion of paints and color, see Chapter 4.
Good quality paint is an essential. Most art shops can sup-
ply the well-known brands that are probably best.

Grumbacher's Hyplars and Liquitex are among the better brands. As some brands of acrylic paints are not compatible with other brands, it's a good rule to use only one brand on a given work.

Colors are sometimes given different names by manufacturers. Similar colors are often available at cheaper prices. See Painter's Supply List on page 16 for further information. Most supply shops have color charts available to assist you in making color selections.

Acrylic paints are available in tubes. These are most suitable for the painting technique described and suggested in this text. Tubes of paint should be stored at room temperature and should always be recapped securely to avoid having any of the paint dry up.

Caps and tube openings must be kept clean. If not clean, the tubes are difficult to cover and to open. Dried on paint can be washed or pulled off the tubes and caps. If the upper portion of paint in a tube hardens, the wrong end of a brush can be pushed through the tube so that the remaining soft paint can flow freely. Tubes that are difficult to open should be placed under hot water.

## Brushes

Quality brushes are as important as quality paints. Good brushes are expensive, but if properly cared for they will last a long time. They are a good investment. Nylon brushes are suggested, but other brushes can be used. No.

2, #4, #6, and #8 Flats would probably meet the needs of most beginners. Flat brushes have a thin rectangular shape. The wide edge of these brushes is used for covering power while the thin edge produces line-like strokes. Paint should be applied to the tip of a wet brush. Unless seeking to achieve a special effect, the artist should use little pressure. A light touch helps to make the paint spread easily and also preserves the shape of the brush.

The biggest brush possible for a task is usually the best brush. Although it might be difficult at first, learning to work with big brushes is well worth the effort. Big brushes help to make bolder, better and quicker painting strokes.

No. 0 and #1 fine pointed brushes are suitable for fine line and detail work. Red sable brushes are best, but nylon brushes are less expensive and require less care. To produce thin delicate lines and details, only the tip of the brush should touch the painting surface.

Toothpicks, sponges, rollers, the wrong end of a brush, or even a finger can substitute for brushes. Only a painter's imagination limits what can be used to create special painting effects.

Care should be taken to keep brushes clean while working and when not in use. Acrylic paint dries quickly and can damage brushes if they are not frequently cleaned. If paint dries on brushes it becomes difficult to clean them sufficiently so that they retain their shape and

flexibility. Wash brushes with water and soap. Avoid hot water. It will damage brush bristles that are held together with glue.

Brushes should be stored flat or with their bristles up in a container such as a coffee can. Brushes left standing on their bristles quickly lose their shape.

## Palette

A palette is used both to hold and mix paint while working. Acrylic paints are mixed on a plastic or disposable paper palette. Other smooth waterproof flat surfaces can be used, including glass, fiberglass or hard surfaces covered with wax paper. To allow space for color mixing, the palette should be at least 9 x 12 inches. The use of the palette is discussed in more detail in Chapter 5.

A palette should be cleaned after use. Wipe off excess paint and wash with water and a cleaning agent if necessary. Disposable pads of paper palettes are available. The sheets are torn off and disposed of rather than cleaned. Paints left over on the palette can be saved if the palette is covered with foil and placed in a refrigerator.

## Canvas Panels and Other Painting Surfaces

Unlike oil paints or watercolors, acrylic paints work well on a variety of surfaces, including paper. Among the surfaces which can be used are canvas panels, stretched can-

vas, canvas paper pads, beaverboard, masonite, cardboard and sturdy paper.

## Canvas Panels

Canvas panels are the most frequently used type of painting surface. The cost depends upon the size. Boards can often be purchased with quantity discounts or when on sale. (Canvas boards are frequently available in discount department stores.) Beginners usually prefer these panels because they are easy to work on, durable, convenient to carry, and easy to preserve.

## Stretched Canvas

Stretched canvases are much more expensive than canvas panels. It's delightful to work on stretched canvas. There's a special feeling involved that is difficult to describe. Every painter should try it sometime.

The cost can be reduced by stretching your own canvas. Canvas stretchers, really rough wood frame sections, can be purchased in various sizes. After deciding on the size of your painting, select four stretchers, two of each size. The strips fit together to form a rectangular frame.

Canvas can be obtained in cut sizes or less expensive rolls. There are a variety of kinds and qualities. The most expensive is linen, but cotton canvas while less expensive can be very satisfactory. Canvas can be purchased ready to use or raw. The ready-to-use canvas has been prepared

with gesso while the raw canvas must be painted with gesso before using. I prefer prepared cotton canvas.

To stretch a canvas, start with a piece of canvas several inches larger than your assembled stretcher frame. Tack the canvas to the side of one edge of the frame. Pull it tightly and then tack it to the opposite edge. Pull and tack the other two edges. If the canvas is not taut, remove the tacks from one side and pull again. Repeat as often as necessary. Additional tightness can be produced by inserting the wedges of wood or plastic which are provided with the stretcher strips. These fit into the joined corners and are often used after the canvas is painted. The corners of the canvas should be pulled into "hospital bed corners" like a sheet and tacked down. Once the canvas is properly stretched, the edges can be stapled and the tacks removed. The stapled edges are smoother and make framing easier.

Handle stretched canvases carefully to avoid a punctured surface or the lumpy effect that can be caused by resting them against a protruding object such as a door handle. Lumps can usually be corrected by dampening the back of the canvas with a wet rag or sponge. If the canvas is punctured the damage is permanent. To avoid problems, stretched canvases should be handled and stored carefully.

## Canvas Pads
Canvas pads are inexpensive. A pad of ten 12 x 16 inch sheets usually costs about $3.25. Many beginners prefer to

use them. The sheets work well if secured to a hard surface such as a drawing board, beaverboard or masonite. The best way to secure the canvas to the board is with masking tape. Use several inches of tape and make a roll with the sticky side out. Attach one to each of the four corners on the back of the sheet and press the sheet onto the surface until the tape adheres tightly.

Tacking down the canvas presents problems since the space covered by the tack heads must be painted later to avoid unpainted circles in the corners. Matching paint is sometimes difficult for a beginner. If the tacks are used beyond the canvas area so that only part of the tack heads rest on the edge of the canvas, less of the painting is lost and there are no tack holes in the painting. Another option is to rule off about a half an inch around the edges of the canvas sheet, tack within that area and exclude these edges from the painting. These edges must be cut off before framing and generally rule out the possibility of using ready-made frames. I recommend the masking tape method.

## Masonite and Beaverboard

Lumber yards offer several good substitutes for canvas boards. Masonite and beaverboard are fine painting surfaces. Either side of the masonite can be used. Your choice depends upon the texture you prefer to work on. Covering the masonite surface with gesso makes painting easier.

The white makes it easier to see what is happening and the gesso covering helps paint to adhere to the surface. Gesso is a white ground that has always been valuable as an undercoating for painting. The disadvantage of using masonite is that it is heavier than most of the other painting surfaces.

Beaverboard has a surface texture that resembles canvas. Some artists cover it with gesso but this is not as necessary as it is for masonite. Both beaverboard and masonite can be obtained at lumber yards in 4 x 8 foot sheets. The sheets can be cut to size for a fee. Another option is to look for scraps from lumber yards or contractors. What are considered scraps are often good sized pieces suitable for paintings. Keep track of the kinds of pressed boards offered by your local lumber yard. Many are practical for paintings after they have been prepared with gesso.

## Cardboard and Paper

Plain cardboard can be used as a painting surface. It's not as durable as other surfaces and not suitable for thick paint. A covering of white paint or gesso can make painting easier. Some of the heavier textured papers can also be used with acrylics, but paint must be applied thinly.

## Old Painting Surfaces

Beginning painters sometimes like to paint over earlier works. The older paintings can be covered with gesso,

white or other colored paint. Paint can even be applied directly over the old surface. Painting directly over old paintings can be confusing and I prefer not to do it. However, many artists I know enjoy doing this and feel that the old work actually helps them create an unusual new painting.

In general, I don't recommend painting over one's work. While it does save money, it results in the loss of the earlier painting. Comparing old works with newer ones helps the painter to see his or her progress. The painter can also study how he or she has solved problems in the past. I feel it is better to find less expensive painting surfaces and save old paintings.

## Easels

An easel makes it possible to work on a painting from the viewpoint of the observer. It's comfortable to paint using one. For a beginner, I'd recommend the simplest and cheapest kind which is a table easel.

A standing easel is best for outdoor work. Good standing easels are constructed to hold the painting securely and to withstand windy outdoor conditions. The easel should be one that can tip the painting away from the glare of direct sunlight. Easels are available in many models at various prices. Careful examination is necessary to determine if the easel is suitable for the individual

painter. An easel is helpful but not essential. Beginners often work on their laps or a table.

## Additional Needs

Painters need water for mixing acrylic paints, for keeping the brush wet so that the brush does not harden, and for cleaning up. Small cups that can be clipped to the palette are available in stores. However, any small water container will work just as well, such as a small jar, an orange juice can, or the plastic cap from a spray can. When painting outdoors it's a good idea to carry a larger container of water to allow for changing the water in the small cup. To avoid problems, never use eating or drinking containers. Rags or paper towels are satisfactory for cleaning brushes and other general cleanup.

# COLOR

Color is a painter's visual voice creating thoughts and emotions. Learning to use color requires a little knowledge of color theory and a lot of actual experimentation. Since there are numerous charts and books available on color theory, this book will deal with the topic in a simple, general way. The use of color is a gradual learning process requiring patient effort. With some understanding of color theory and experimentation your own unique palette of color will develop.

## Color Theory

Scientific color theory originates from the source of color which is sunlight. White light actually contains all colors. The colors become visible to the naked eye when sunlight

is viewed through a glass prism or when you see a rainbow. Black is the total absence of sunlight, as experienced on the darkest night, and is the absence of all color.

A painter usually uses twice as much white paint as any other color. It cannot be mixed itself but is frequently used to lighten other colors. When white is mixed with another color to produce a lighter value, the result is called a tint. Pink, a mixture of red and white, is a tint of red. White is often used on its own, as well as in mixtures.

Black has been excluded from the list of recommended paints for beginners. Black never occurs in nature. What appears to be black is actually a combination of dark colors. When mixed with other colors, black paint tends to produce a muddy, dull result. A blackish, dark color can be obtained by mixing red and blue with a little green. Black can be useful in doing abstract styles of painting, but the beginner is wise to avoid mixing it with colors, at least at first. Black should be used with caution. Many experienced painters do use black and use it well—usually sparingly. Others do not use black at all.

## Primary Colors

From scientific color theory, we know that all colors can be made from three primary colors: red, yellow, and blue. (The exceptions are black and white.) When two primary colors are mixed together, the result is called a secondary color. The three secondary colors are green, orange and

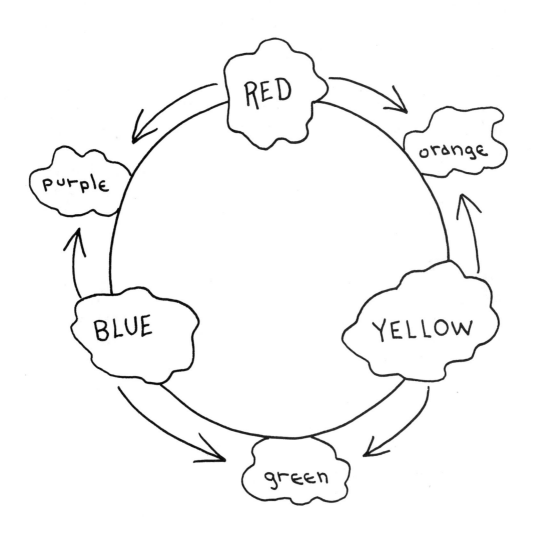

purple. Green is a mixture of blue and yellow; orange is a mixture of yellow and red; and purple is a mixture of red and blue.

Other colors are combinations of primary and secondary colors. Thus blue-green is a mixture of either blue and green, or blue with a small quantity of yellow. Brown is a mixture of all three primary colors with more red and yellow than blue.

Gray is a mixture of the primary colors and white. Cool grays require the addition of more blue, while warm grays require extra red. Add more or less white to obtain lighter or darker shades.

## Paints

Paints are composed of a variety of natural and synthetic ingredients. Thus mixing according to color theory does not always work. Beginners, especially those who wish to work from nature, might find the following list of colors useful.

White
Cadmium Red
Cadmium Orange
Cadmium Yellow
Chromium Oxide Green
Manganese Blue
Yellow Ochre

The red, blue and yellow suggested will work fairly well to produce most of the secondary colors. However, orange is sometimes difficult to mix and so it is wise to purchase a tube.

Yellow ochre is a golden tan color and is sometimes called the sunshine color. It is often mixed with other colors to give the feeling of sunlight in nature paintings. It's also useful in making a variety of browns and warm greys.

Greens mixed by the painter are better than most of the greens that come in tubes. Greens result from mixing blue and yellow, blue and yellow ochre, or blue, yellow and yellow ochre. Chromium oxide green, which is very useful, is a kind of earth green. It is not an easy color to mix and should therefore be purchased.

Those interested in painting portraits and human figures may want to purchase a tube of one of the so-called flesh colors. If you plan to paint flowers, you may decide to add a tube of purple paint to your list.

The color list I have provided gives the universal names for good paint colors. However, it is possible to make substitutions which will save money. Since the cost of each tube of paint is determined by its composition prices vary. Look over color charts available in art shops and weigh both personal choices and cost factors. Some companies do manufacture colors comparable to but cheaper than those on my list. Some examples are mentioned in Chapter 3 of this book.

## Mixing Colors

Many beginning artists feel they have to buy every imaginable color, in a tube, ready to use directly on their paintings. It is an expensive tendency. In addition, the painter cheats himself or herself out of the delightful experience of mixing colors. The painter's own way of mixing colors is often what makes a painting unique.

The best way to understand color theory is to mix colors. Preparing and using colors on a palette are discussed in Chapter 5. While mixing is a trial and error process, it is possible to succeed in producing a desired color if you keep color theory principles in mind. It is usually possible to determine how to improve a color. If you've combined red, blue, green and white to make gray, and the result looks somewhat purple, add more green. If the result seems brownish, add more blue. If yellow and blue have been mixed to produce green, and the result is blue-green, add more yellow. If the result is yellow-green, add more blue.

White is not a strong color and must be used in quantity to lighten a color. Try putting a blob of white on your palette and adding a small amount of color to it. More color can easily be added and the chances of mixing too much of the lightened color will be lessened. Remember that red is a strong, "loud mouth" color and should be used sparingly when mixing.

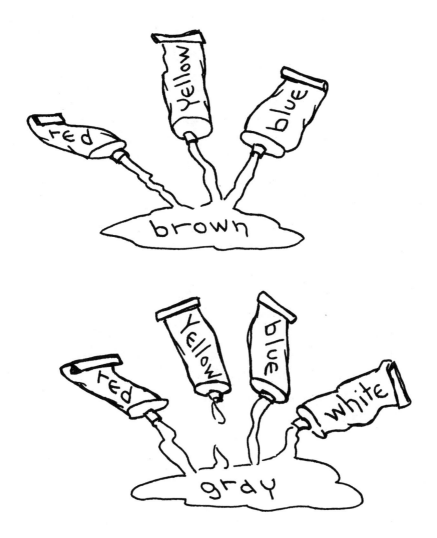

One of a painter's biggest problems can be trying to duplicate mixed colors. It can be done only by recalling exactly which colors were originally used. Remembering can be made easier by using a limited palette. If you have put only one blue on your palette, then only that blue can be contained in any mixture. If several blues are on the palette, it is necessary to remember which blue or combinations of blue were used. The ability to duplicate mixed colors eventually comes through the development of a kind of "card-player's memory." The final test is careful comparison of the new mixture with the desired color. The whole process becomes easier with practice.

Some people find it helpful to keep charts of their color mixtures. Place a small amount of mixed color on a piece of paper and note the colors and amounts used in the mix. Swatches can be collected and saved for reference.

The way color is used is a very personal part of painting. Some artists choose to be bold and use bright or contrasting colors. Others prefer soft blended combinations. Part of the delight of painting is the discovery of your own color expressions.

# COLOR MATH

RED + YELLOW = ORANGE
YELLOW + BLUE = GREEN
BLUE + RED = PURPLE

RED + YELLOW + BLUE = BROWN
RED + BLUE + GREEN = BLACKISH DARK
RED + BLUE + GREEN + WHITE = GRAY

RED + ORANGE = RED-ORANGE
ORANGE + YELLOW = YELLOW-ORANGE
YELLOW + GREEN = YELLOW-GREEN
GREEN + BLUE = BLUE-GREEN
BLUE + PURPLE = BLUE-PURPLE
PURPLE + RED = RED-PURPLE

# MAKING
# A PAINTING

Making a painting is a very personal form of creativity. Being told "how to" make a painting can interfere with personal creativity. However, there are some general guidelines which may be helpful for beginning painters. There are also some universal considerations that may be helpful. What follows is my personal view of making a painting. It has evolved from my own painting experiences and from working with dozens of painting teachers and several thousand students.

## Sketching

Making a painting begins with selecting a subject and working out a composition. Sketch paper and pen or pencil are often used to work out rough drafts. It is helpful if

sketches are made in proportion to the painting surface. It is also advisable to figure out if the subject will work best as a horizontal or a vertical.

Time should be spent arranging and rearranging the parts of the painting in an effort to achieve an interesting composition. Changing the size, shapes and relationships of objects can create different compositions and moods. The painter should explore the possibilities. Even when painting from life, what is seen should be considered only as a starting point. The goal should be personal expression rather than the precise recording of what is seen.

From your sketches, select the one you decide to use for the painting. If you are not satisfied with any parts of the sketch, resketch those parts until you are satisfied. Working on canvas is easier if you have done preliminary sketching.

## Initial Layout

It is helpful to indicate the horizon line on the canvas before sketching. Using a regular or charcoal pencil or a paint wash make a rough drawing on the canvas. Avoid small pencil details which can be difficult to paint in with a brush. Study the completed sketch and make any desired changes. Check both whether the sketch accomplishes its purpose and whether the composition works well. It's easier to make changes at this stage.

If you haven't used a paint wash, go over the pencil or

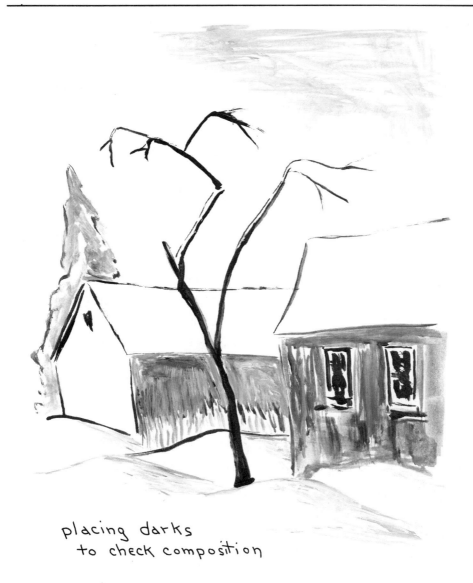

placing darks
to check composition

charcoal lines with a paint wash. To make a wash mix small amounts of red and blue paint on the palette. Add water to make a thin but not runny paint. Using a brush and this neutral paint, go over the lines of the sketch. The paint wash will dry in a few minutes. If you've used charcoal pencil, the charcoal should be wiped off with a rag or paper toweling. Erase any pencil marks which show through the wash. At this point, some painters also fill in all the dark areas in the painting with wash. This helps in visualizing the composition.

## Painting

The palette should be made ready before beginning to paint. The paints are usually placed on the edge of the palette which will be held or placed farthest away from the painter. By always placing colors in the same order, the artist automatically knows where a color is. Paints are often lined up according to the color wheel, beginning with white followed by red, orange, yellow, yellow ochre, green and blue. Squeeze about as much paint as you would toothpaste on a toothbrush. Extra white paint, usually double the amount of the others, should be squeezed out.

After the paints have been placed on the palette, the largest portion of the palette should be free for mixing. Paint to be mixed should be moved to a free space on the palette with a clean brush or one from which excess paint has been removed. To avoid difficulty in mixing and

painting, the brush should be kept wet at all times. Keep paint in blob form by mixing only on a small area of the palette. If acrylic paint is spread too thin, it begins to dry before it can be used.

Because it has an effect on the appearance of everything else, sky is usually painted first. Backgrounds are also painted first. It's sometimes necessary to paint over details and edges of some shapes in order to have background colors flow and look complete. Details and overlapping can be retouched later. By covering large areas first, it's possible to get a feel for the overall look of the painting. Blank areas on a painting detract from every part of the work.

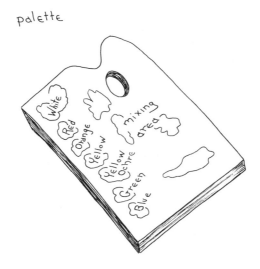

## Blending

Blending colors is important in painting. Gradual blending of colors can produce many desirable effects including depth, form, texture and design. Through blending, colors can be made lighter or darker, grayer or brighter. One color can move into another. For example, blue can gradually become blue-green and/or green.

Each painter can develop his or her own best method for color blending. The paint can be blended on a palette as it is used. One color mix can be changed gradually as it is used, or different mixtures can be made up and used as needed. Also if the paint is wet, blending can be done right on the canvas. Brush strokes can help in blending. Blending is not essential and its use depends upon the painter's discretion. It is an exciting part of the painting experience.

## Details and Texture

Details and texture can be added to a painting in many ways. Toothpicks, sponges, the wrong end of a brush and even fingers can be used. Ways of working out detail and texture are limited only by the painter's imagination. It's sometimes easier to add small details after a painting is dry. The painter can rest his or her arm on the work and thus increase control over what happens. When adding details, the painting can be placed upside down, flat or any way that makes it easier to work on. Details and tex-

blending

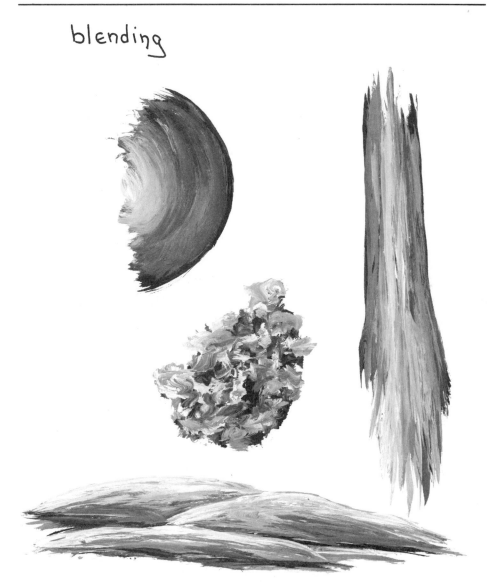

tures being added should fit in with the painting as a whole.

## Viewing Your Work

It's good to step away from a painting at intervals in order to view it as a whole unit. Throughout the painting process it's wise to keep in mind that paintings are made to be viewed at a distance.

One of the painter's major decisions involves deciding when a painting is finished . . . when to stop. An overworked painting loses its freshness and appeal. At the same time, a painting should have a finished look. The decision is easier if the painter has done a lot of initial planning because such planning does include visualizing the finished painting. When in doubt, it's a good idea to take time, even days or weeks, to study the painting. Viewing the work in a frame is often helpful. Seeking opinions from others is good, provided your own judgment prevails.

# SKETCHING AND DRAWING

The key to drawing is found in sketching and then studying the results to see if observations and feelings have been captured. Try to determine what marks and shapes are needed to improve your sketch. Ask yourself questions. Is something bigger or smaller than it should be? Do lines slant? Do lines curve the way they are when you observe? Are proportions correct? Do objects relate to one another? Did you show only the parts of things that you actually see? Have you captured what was important to you? Does the work have the desired feeling? Asking your own questions, finding your answers and making corrections will result in good original sketches.

A sketchbook is a helpful tool. You can review past sketches and make corrections as your sketching ability

improves. A collection of sketch notes is useful for painting. Sketches can include all kinds of things and parts of things: trees, hands, feet, plants, houses, streets, doorways, faces, figures, corners of rooms, books, vegetables, bottles, old shoes, etc. Sketches can be rough quickies or detailed studies and can be from real life or fantasy.

Using a sketchbook is probably the most creative and rewarding approach to learning to draw and sketch. Although this approach may seem the most difficult, it is highly recommended and almost a necessity.

## Perspective

Perspective in drawing is based upon what is seen by the eyes. It deals with what we actually *see* rather than what we *know* about an object. Perspective is somewhat complex, and developing an understanding of it takes time. Developing your own powers of observation is part of understanding perspective. The following information provides a continual reference.

## Horizon Line

To understand drawing perspective, a person must first understand how the human eye deals with the horizon line. When a person looks out into the distance, the earth and sky always appear to be divided by a straight line that is off in the far distance. This line is called the horizon line. The horizon line is very clear when you look out to

sea on a calm day. In other situations, the line is obscured by trees, buildings, mountains, or the interior walls of a building. Whether visible or obscured, the eye can always locate the horizon line.

eye level locates the horizon line

The location of the horizon line depends upon where you are. It's always at your eye level; it is a horizontal line parallel to a line that could be made between your two eyes. If you are seated or lying close to the ground, your horizon line is low. It is also quite close to you. If you are standing, the line will be higher and farther away. If you are standing on an observation tower at an airport or in a forest, the horizon line will still be at eye level. Since the horizon line is much higher, you can see a distance of many miles. This is why sailors climb masts and why a

whaling captain's home would often have a railed deck on the rooftop. Sailors sight land from mast tops, and a whaling captain's family could watch for the return of ships and be the first to know of homecomings. Because many ships were lost and wives waited in vain, these structures are called widow's walks.

The horizon line is as low or high as your eye level.

The area below the horizon line is land and water. The lowest portion of this area is closest to you. As you move toward the horizon line in a view or sketch, you are also moving farther away. Spaces toward the horizon line gradually represent greater distances. Several inches up or down on a sketch can actually represent distances of miles. Objects in the lower section of a view or sketch are large and close. Objects closer to your horizon line are farther away and appear to be smaller. Objects on the horizon line are often too distant and small to be seen by the eye.

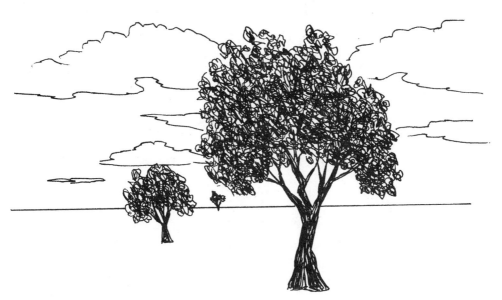

things in the distance look smaller

The area in the uppermost portion of a sketch, above the horizon line, represents the area nearest to you. Clouds, birds, planes and other objects in this upper sky are closer to you and therefore would appear to be larger than things in the lower sky. Objects near the horizon line will appear to be smaller and less distinct.

## Parallel Perspective

Parallel perspective is also based upon the way things appear to the human eye. Lines made by the edges of objects going back into space seem to slant toward the horizon line. Parallel lines going back into space appear to slant and eventually meet at one point on the horizon line. The point where parallel lines meet is called the vanishing point. None of this happens in reality. The top and bottom edges of buildings do not slant. The slanting lines are what is seen by the eye and are useful in drawing. The realistic painter needs to make use of one and two point parallel perspective.

## One Point Parallel Perspective

One point perspective applies when you're sketching box-like shapes which are facing you. If the object is directly in front of you, you see only one side and so perspective is no problem. In other instances, however, your eye will also see a portion of one side and possibly the top or bottom. To achieve the correct perspective, first determine

one point perspective

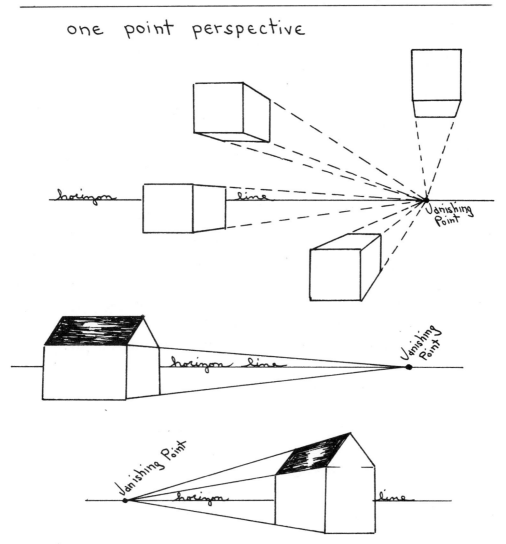

and mark off the horizon line on the sketch. Next, draw the front surface of the shape, keeping to the proportions of the actual object. Study the object carefully and you will see that all the receding horizontal lines in the object appear to slant toward a vanishing point on the horizon line. The location of the vanishing point depends upon the viewer's position. The vanishing point can be close to the object or out beyond the edge of the sketch as indicated in the illustrations.

The vertical lines in the receding parts of the object appear to be shorter. The length of these lines is determined by the space between the lines slanting to the horizon line. The lines are drawn from the top to the bottom slanting line. A better understanding of one point parallel perspective will come from studying the sketches given in this book and from doing your own sketches.

## Two Point Parallel Perspective

Two point perspective involves sketching a boxlike shape with a corner facing you. In this situation, the corner line appears to be the tallest. Both sides of the shape seem to slant back toward the horizon line and there is a vanishing point for each side on the horizon line. Both sides of the shape are foreshortened. Compare the following sketches with your own observations.

two point perspective

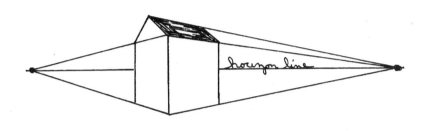

horizon line

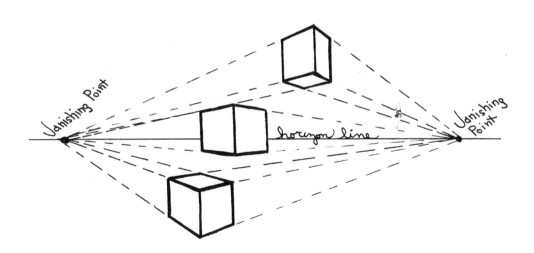

Vanishing Point

horizon line

Vanishing Point

## Cylinder Perspective

To the human eye, balls and sphere-like objects always appear to be round; however, the appearance of cylinders is greatly influenced by the position or perspective of the viewer. When viewed up close or head-on a cylinder top or bottom has only a circular shape. The same cylinder, when lying horizontally, and viewed from the side or from a distance will have a top or bottom, and parts of the sides. The upper and lower edges of the sides, though actually parallel, will appear to slant toward the horizon line. For sketching purposes, one point perspective should be applied. The length of the cylinder should be foreshortened in the drawing.

When drawing an upright cylinder, the center of the cylinder is closest to you rather than the vertical edges. The top and bottom are seen and should be drawn as ovals or half-ovals. The tops of cylinders below the horizon line appear to have an oval shape. When above the horizon line, the cylinder top appears to have a half-oval shape. The actual top surface will not be visible. Note the examples in the drawings.

If the entire cylinder is above the horizon line, the bottom circular shape will show as an oval. The size of these ovals depends upon how close the oval is to the horizon line. The oval shapes will be rounder as they move away from the horizon line. Ovals near the horizon line will appear long and thin.

cylinders

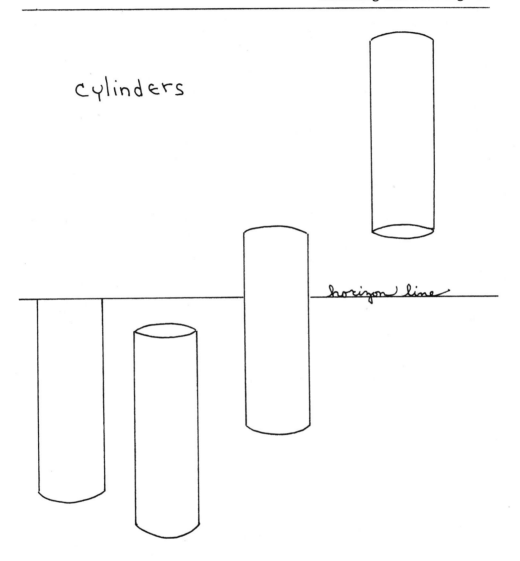

horizon line

A cylinder shape beginning above the horizon line and extending below the horizon line will not have top or bottom circular shape showing. The top half of an oval marking the shape of the top edge of the cylinder will curve toward the top edge of the sketch. The lower half of an oval making the bottom edge of the cylinder will curve toward the bottom of the sketch.

## Position and Size

Distances can be indicated by the position and size of objects in a sketch. The line marking the bottom of an object marks its distance from you. This line also helps determine the size of the object. Close objects should be drawn toward the lower edge of the drawing and be made larger. Things near the horizon line should be made smaller and placed higher on the drawing.

Look at a group of objects that are similar in size, but located at various distances from you, such as a row of houses. Stretch out your arm in front without bending your elbow. Spread your hand out and up. Your hand will partially block out the house nearest to you, but it will completely block your view of some of the houses farther back. The effect of distance on the apparent size becomes clearer when you see that your comparatively small hand can block out whole buildings. Objects in the distance appear to be smaller than those closer to the viewer.

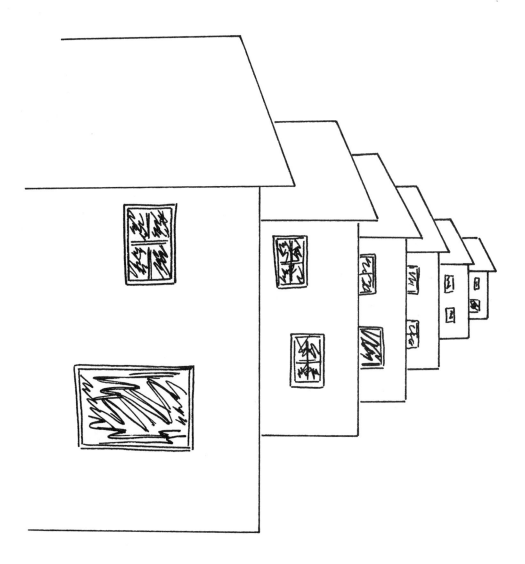

## Overlapping

Overlapping is another point to be considered when portraying distance in a drawing. Closer objects sometimes obscure parts of things which are farther back from a viewer. For example, if you draw a tree in front of a house, it will begin lower on the sketch than the house behind it. It will also overlap or hide part of the house. The overlapping object, that is closest to the painter, should be drawn lower on the sketch than the object being obscured. Test overlapping by studying and sketching some objects which overlap.

## Atmospheric Perspective

Things that are close to a viewer appear to have stronger lines, brighter and more contrasting colors, and more numerous details, including texture, than objects that are in the distance. Things that are far away look thinner and more delicate. Colors are softer and grayer and have less contrast. The perspective which applies when painting objects in the distance is called atmospheric perspective. The atmosphere has an effect on the way things look in the distance.

overlapping

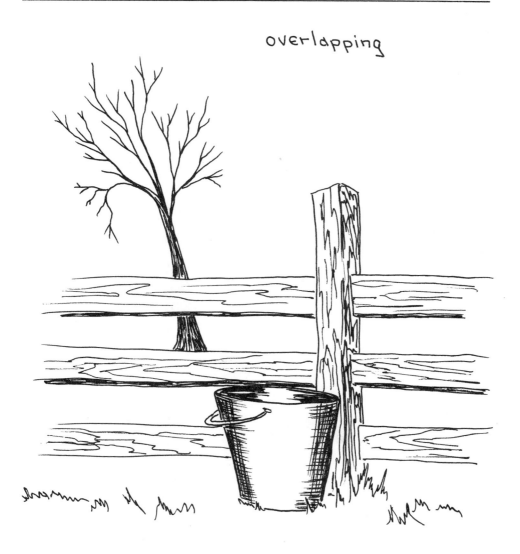

# SUBJECT CLUES

Deciding "what to paint" is one of the painter's first problems. The choice is both personal and important. Initially, it's wise to choose simple subjects and compositions. Imagination, feeling, memory and observation can provide subjects.

Observation, followed by painting what is seen, can be the basis for a painting. An understanding of subject matter based on observation is a valuable foundation for any painter. This chapter is offered for those who wish to consider observable subject matter, regardless of the painting style chosen.

All outdoors, and indoors too, provide endless subject matter. If observation is to be the direct basis of a painting, the subject matter must be rearranged, organized and

simplified in a selective way. This kind of moving things about (discussed more fully in the chapter on Composition and Design), is what makes painting an art.

Working outdoors can be fun, but if it's not possible to go outdoors window views provide many possibilities. Indoor scenes can include still lifes, or posed figures. A still life can be arranged or a person can be posed to create the beginning of the composition. Lighting, placing and relationships can be determined prior to sketching.

An "indoor way" of painting outside involves going out to a location to make sketches, color notes and, sometimes, to take photographs. There is also a need to rely on memory. Painting off location poses problems, but is done successfully by many painters.

Slides, photographs, and magazine pictures, offer good substitutes for actual going out to a location. A major difficulty posed by using slides is to find sufficient darkness for proper viewing while providing enough light to paint. Slides also require using rather expensive projection equipment. Photographs and magazine pictures are easier to use, although the coloring is apt to differ from nature.

Whether using real or two-dimensional sources, the artist should select, arrange and organize the subject matter into his or her own composition. To be creative, copying must be avoided.

Existing paintings, drawings and illustrations are not good subject matter. It is almost impossible to avoid copy-

ing the composition, originality and/or technique of the original artist. Copying is never art.

## Sunlight and Basic Shapes

Because sunlight affects everything in realistic painting, the location of the light must be determined in the beginning and must remain constant. Since the tops of objects receive the most direct sunlight, they should be painted lightest. This holds true even on gray, rainy, days. The sides of things facing the sun are lighter than the sides away from the sun, but not as light as the tops. The patterns formed by light and shadow joining together can provide the whole basis for a painting's composition.

To create sunlight effects, mix white and a touch of yellow, yellow ochre or orange with the color of the object. Shadows are made by adding blues or purples to the color of the object in shadow.

Traditional art always placed an emphasis on the basic shapes: the square, the pyramid, the sphere, the cone, and the cylinder. It was once believed, and still seems to be true, that all shapes in nature stem from and relate to these basic shapes. The shading of basic shapes is determined by the location of sunlight and/or other light sources. An understanding of the effect of light on the appearance of these shapes is valuable in painting any object.

Squares and pyramids are angular shapes with flat

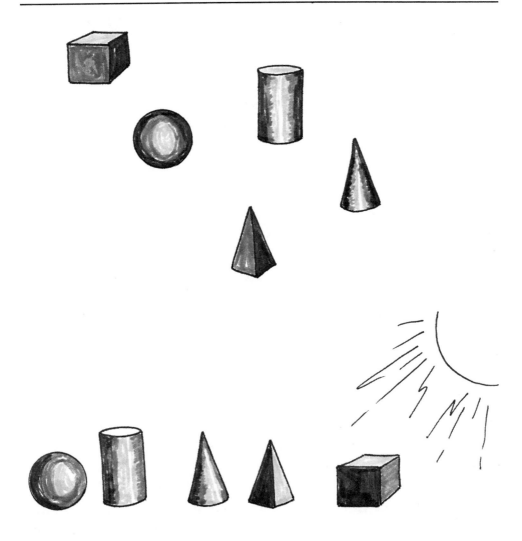

surfaces. In normal light, the top of a square is the lightest surface. One of the visible sides of a square or pyramid appears lighter than the other because it is the side exposed most directly to the light source.

Both shape and lighting affect the shading of the sphere, cone, and cylinder. The outside edges of the rounded portions are always farther away and thus darker, while the center of these shapes is nearest and lighter in appearance. When light reflects on these shapes, the change in color value is very gradual. This can be readily seen when you view light hitting a rounded object head on. If the source of light is on either side of the shape, it will cause that side to be slightly lighter. Curved shapes with smooth, shiny surfaces have a highlight. This appears as a lighter spot on a sphere or as a thin light line on a cylinder or cone. The highlight is the space most influenced by the light source and should be painted the lightest color on the shape.

## Clues

The following information deals with some possible ways to approach painting frequently used subjects. These clues are not meant to limit or control and should be used only to the extent that they seem helpful and valid. Creative painters should search for new and different essences in subjects, and develop their own ways of presentation.

These clues include a small potpourri of basic concerns common to most beginners.

## Sky

Unless you're painting a white object in the sky or portraying a stormy day, the sky will probably be the lightest area of an outdoor painting. The sky is brightest overhead, and usually seems to be softer, grayer and pinker in the distance. Sky is more than blue and white. Green, pink, orange and/or yellow are sometimes blended into the sky's color. The sky on a rainy day is generally a multicolored gray.

The shape of clouds can vary from flat and thin to round and deep. Clouds high in the sky are closer and should be painted larger, with more detail and contrast. Distant clouds should be painted lower toward the horizon line and should be thinner, less detailed and more blended into the surrounding sky. Sunlight gives the upper portion of cloud formations, or wherever the light hits the clouds, a slightly yellow or orange-white appearance. Under portions of clouds are in shadow and thus should have a grayer or darker cast. Painting clouds involves a great deal of blending of colors.

## Water

When painting the sea, it should be remembered that water has a definite horizontal appearance, especially in the

sky

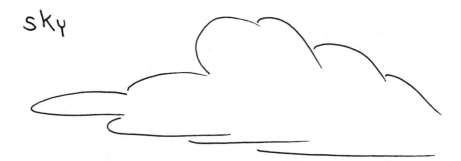

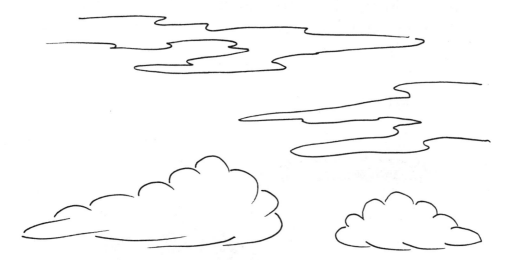

distance. Zigzag shapes of color and values can convey a sense of the currents and tides. Waves on the water's surface are bulges in motion. Each wave should begin and end on the same horizontal plane and should blend into other waves. Waves receding into the distance diminish in size and finally cannot be seen. The kind of sunlight and the shapes of the waves determine the shading needed.

Since water has no color of its own, except a quality of green, it is usually a darker reflection of the sky. Water can look light, dark, gray, blue or blue-green. The exact coloration is dependent upon many factors including the color of the sky, the wind, temperature, currents and tides. Water should be observed and studied. Usually you will have to simplify what is seen.

water

## Reflections in Water

If water is calm, reflections are simply an upside-down view of what is above and beyond the water. Reflections may look foreshortened or elongated. Light colors tend to reflect as slightly darker, while darker shades tend to appear slightly lighter. Reflections in moving water are distorted, and broken by the water's color. Objects in the distance reflect in water but without detail.

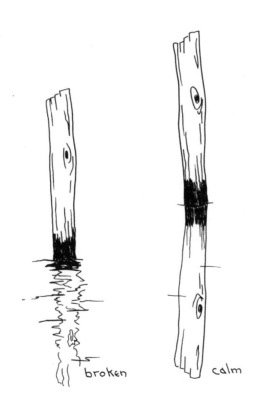

broken                    calm

## Trees

Trees are solid wood growing out of the ground and topped by leafy clumps that often combine to create irregular, rounded shapes with bits of sky and branches peeking through. The skeleton formed by the wood is the thickest in the trunk portion. Gradually, gracefully, and literally the wood branches out. The tree skeleton reaches toward sunlight, eventually branching out into many twigs. The skeleton is visible on many kinds of trees during the winter and leaf-covered at other times. The coloring of leaves changes with the seasons. Spring leaves are soft, yellow-green and delicate. In summer they're a rich and varied combination of greens. The coloring of fall leaves is especially varied, and beautiful and different for the various kinds of trees. The irregular shapes formed by both wood and leaves are filled with designs and patterns.

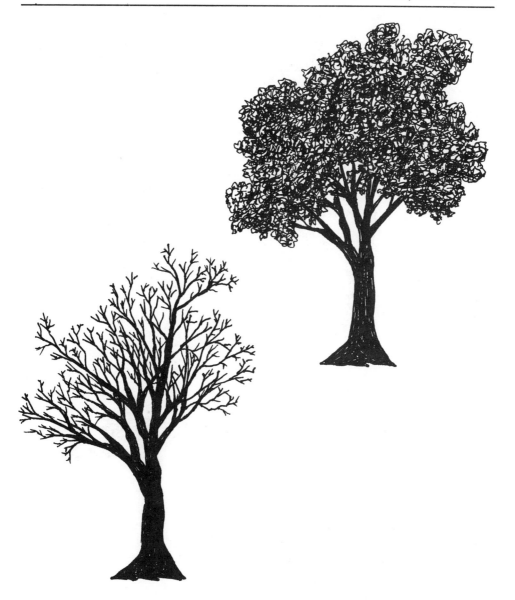

## Grass

Grass is apt to be a combination of colors, including various kinds of green, blue, yellow, yellow ochre and even red. Most paint tube greens seem artificial, so many artists mix their own greens by using blues and yellows. By using vertical brush strokes you can create the effect of tall grass or grass that is close. Tall grass often seems slightly darker near its roots. Distant grass requires horizontal brush strokes to help it stay down and to create the effect of the grass receding into the distance. The color of distant grass is apt to be softer or grayer.

grass

## Shadows

When an object blocks the flow of sunlight, a shadow is formed. In the early morning and later afternoon, shadows are long and thin. Near noon, most shadows disappear. Shadows are usually cool looking with a dark bluish value. Their shapes and sizes are governed by perspective and the position of the sun or other light source. Foreshortening shadows is important. This is done by making the shadow shorter to create the effect of receding into the distance. An object set upon a surface, for example a vase or pitcher on a table, often has a shadow line. This is a line-sized, dark spot where light never seems to penetrate.

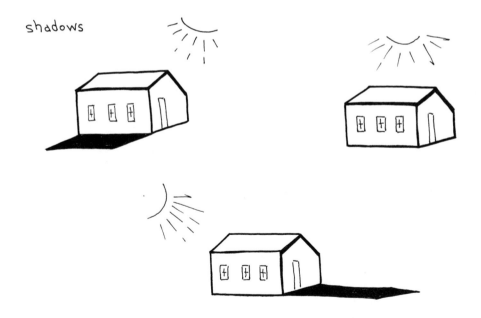

shadows

## Mountains

Mountains need to be in perspective in order to show their size and distance. The coloring of mountains is effected by the atmosphere. For example, distant mountains have a bluish or grayish look.

## Roads

A road travels back to a vanishing point on the horizon line. Curves in a road cause new, additional vanishing points. The width of roads parallel to the bottom and top of a painting must be foreshortened a great deal and will often appear as little more than a thin line. The accompanying drawings illustrate these points.

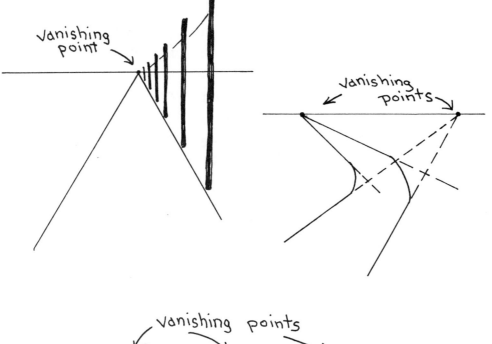

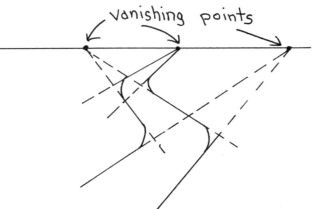

## House and Buildings

The drawing of houses and buildings is governed by parallel perspective. A common problem involves sketching roofs. The slants of the two edges of a roof pitch are always drawn parallel to each other. The peak of a roof, when viewed head on, is simply placed in the center. In a side view, the location of the peak can be determined by use of the trick shown in the diagrams. A side of a building going back forms an irregular rectangle. If an "X" is formed from the four corners of the rectangle, a straight line up from the center of the "X" will give the location of the peak, as in the illustration.

Sides of structures that face the sun are lighter. In bright outdoor sunlight, the interior of buildings, as seen through windows and open doors, appears dark. Bright or light windows are seen only when it is dark outdoors and the indoors are lighted.

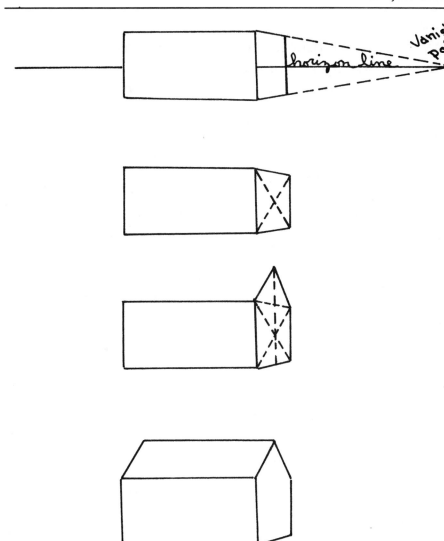

## Portraits

Observation must precede portrait painting. A portrait's success depends upon blending colors and values and the use of delicate lines. The nose and other facial features are molded curves. Attention to the shape and proportion of the head, location and shape of the eyes, ears, nose, mouth, forehead, cheeks and chin are very important. All of these elements change when the head is viewed from various angles. One of the most effective angles for sketching is a three quarter view of a face.

# portraits

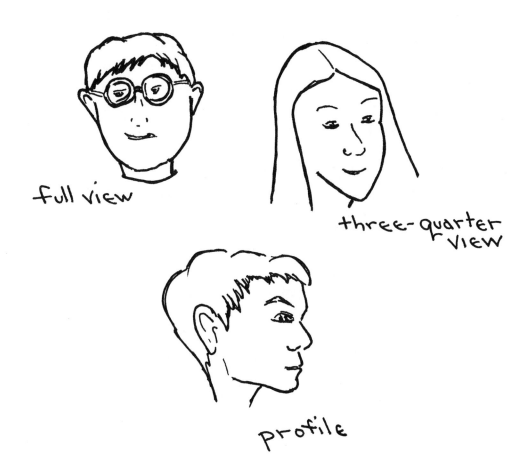

full view

three-quarter view

profile

## Figure Drawing

Using stick figures as a starting point for sketching the human figure is a familiar technique. Beginning with ovals rather than straight lines seems to be more effective and rewarding. Ovals are used to approximate the areas of the body, with each oval representing a section between human joints. For example, from shoulder to elbow and elbow to wrist are shown by long thin ovals, while a head is shown by a rounder oval. Since joints mark the moving parts of the body, working with ovals that begin and end at joints makes it possible to show and almost feel action. Working with oval figures is a way to develop an understanding of human proportions as well as a feeling of movement. Oval figures can be reworked into realistic figures by concentrating on the actual appearance of the human figure while making additions and making corrections.

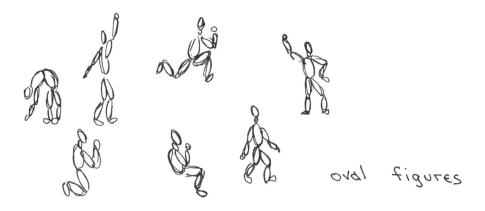

oval figures

A time-honored approach to figure drawing is the use of gesture drawings. Sketches are made from a posed model with an attempt to concentrate on the figure's total gesture rather than on parts and detail. Sometimes, the pencil never leaves the paper. The sketches are always done quickly. Practice in gesture drawings also helps to develop an understanding of the total human figure in action.

# COMPOSITION AND DESIGN

**Elements of Art**

The composition and design in a painting are a form of action made by the elements of art: lines, shapes, values, colors and textures.

*A LINE* is a mark that must have only length. It can wiggle, zigzag, curve, slant, wave or travel straight.

*A SHAPE* is what happens when a line meets itself.

*COLOR* is a speck of the rainbow that can cover a shape.

*VALUES* are the lightness and darkness of color that range between dawn and dusk.

*TEXTURE* is a touch and feeling of a surface that can be seen.

# The elements of a painting

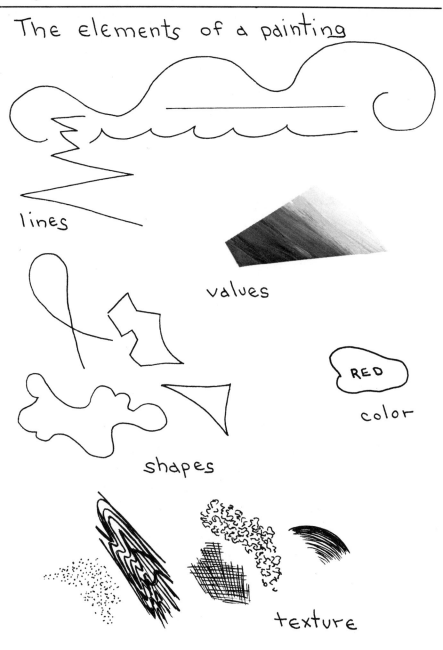

lines

values

shapes

RED

color

texture

A painting communicates a message. It can tell a story, portray an idea, represent an attitude or feeling, or do a combination of these things. The painter uses lines, shapes, values, colors and textures to accomplish his or her purposes. Beyond the message of the painting, there is a quality of action created by the elements of art. This action is called the composition and design.

The elements of a painting should be arranged so that the viewer's eye travels through the work in an interesting and compelling way. This eye movement, which causes the viewer to dwell in and on the painting, can be created by strongly dramatic or softly subtle use of the elements. There are endless variations and combinations available to the artist.

There are numerous hints for creating the kind of eye movement mentioned above. The four rough diagrams which follow illustrate some simple composition outlines. Arrows indicate the path the eye might travel. In each instance, the goal is to have the eye travel throughout but never beyond the space of the painting. Combinations of these basic compositions are often used by painters whose goals are to create original compositions with both action and holding power.

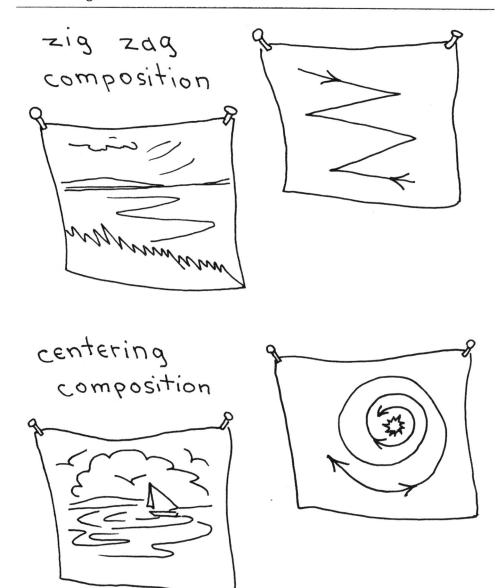

zig zag composition

centering composition

big X composition

all around composition

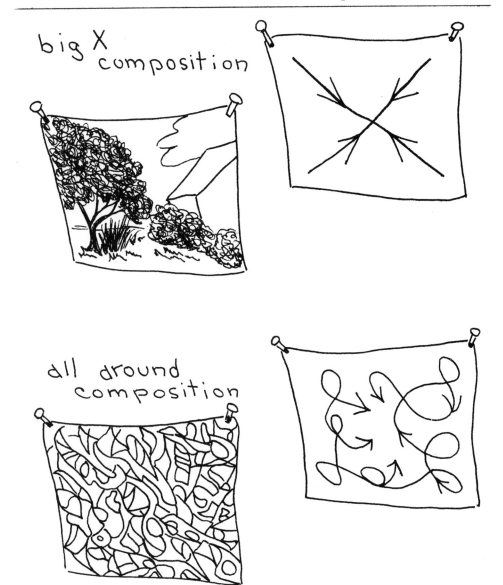

## Principles of Art

Good composition depends upon creative use of all the principles of art: balance, rhythm, harmony, variety, and unity. These universal principles are important not only to painters, but also to flower arrangers, clothing designers, architects, landscapers, interior decorators and composers.

## Balance

Balance in a painting refers to a pleasing stability and integration of the elements in a work. Desirable balance results from the use of odd combinations of elements with weighed evenness. There are two general approaches to balance, formal and informal.

Formal balance is the achievement of an obvious equality and stems from the repetition of like elements. It's a primitive form of balance and can be rather stiff and uninteresting.

Informal balance is more complicated and thus more difficult to achieve. Different combinations of elements are used to balance each other. For example, a large soft shape might be balanced by a dot or line of bright color. Informal balance is subtle, unusual and creative. It is what painters strive to attain.

A way to check balance is to view a painting right side up, upside down, and on each of its sides. The painting should not look lopsided or top heavy from any of the four views but should have an overall balance.

# formal balance

# informal balance

## Rhythm and Harmony

Rhythm is the flow in painting comparable to the beat in music. It is a quality that produces different rates of eye movement in the viewer. Just as the whole notes in music hold the ear, certain lines, shapes, colors, values and textures in a painting hold the attention of the eye and the mind in a painting. The eye is moved about the painting according to the beat or timing caused by its elements.

As it does in music, harmony in painting refers to a kind of blending or belonging together. All the elements in a painting must appear to be joined, as if they belong and flow together.

Rhythm and harmony are difficult to illustrate with examples. They are essentially qualities which develop from the painter's own awareness. You should attempt to feel and strive for rhythm and harmony in a search for your own solution.

## Variety and Unity

Variety is one of the keys to interesting, creative paintings. It is the quality that encourages the eye to move about the painting's surface numerous times and in various ways. There needs to be more than one kind of line, shape, color, value and texture in a painting. Things repeated in a painting should vary in size, shape, color or some other way.

Unity brings wholeness to painting. All the parts must work together to create one whole and unified work. The elements and principles of painting, indeed of all art, must be composed and designed creatively. The results in painting are creative communication with quality expression.

# PAINTING STYLES

Painting styles stem from the unique creativity within individuals. Deep within every painter there is a creative spark which ignites and glows when he or she finds his or her own painting style. A lot of frustration can be avoided, and delightful satisfaction can be gained, if the beginning painter can dare to let go, to feel free to experiment in search of his or her special creativity.

Some knowledge of the broad possibilities as exemplified by well-known painting styles is important. A painter should never consider painting as a "one way" or one-style activity. It is wise to study the work of other artists, particularly those who are recognized as great, and learn something about all of their varied styles. This can be done by visiting art galleries and art museums and by

browsing through art books. Study of current painting styles also helps because it offers the opportunity to see new styles developing.

There are many generally recognized painting styles. Some of the best known are discussed briefly in this section. Suggestions are also offered on how to work toward painting in these styles. The reader is urged to study many examples of these and other styles and to experiment with the ones that are most appealing to him or her.

## Realism

Realism is an older art form that continues to appeal to many artists and viewers. The emphasis is on technical skill and the painter includes all kinds of detail. The challenge is to make the two-dimensional surface of the canvas convey a three-dimensional view of the scene or object. The goal of realism is photographic clarity.

Realism requires that you concentrate on how things look and work on mastering the drawing and painting skills. Powers of observation and patience are required if you are to paint realistically. The results can be very pleasing, as the study of the paintings of Andrew Wyeth can make clear. It should be remembered that each of Wyeth's works took a great deal of time to produce.

Good composition remains an essential aspect of realistic painting. It must be coupled with the technical skills

necessary to do representation. If you choose to paint realistically, I suggest you judge your work more by its composition than its realism. It is wise also to concentrate more on your improvement than on the results achieved in one particular work. While any lack of realism may detract from your goal, it need not have to take away from the beauty of the finished work.

## Impressionism

While in modern times impressionism is considered to be quite realistic, early impressionistic painters caused quite a stir. Their work was much criticized because it lacked realism. Today, the lack of realism is not considered a problem and many impressionistic painters are considered to be realistic by many people.

To get an idea of what an impressionistic painter might paint, squint your eyes while looking at a scene. Note the details will blur and a kind of atmosphere will be emphasized. The glow of sunlight and the shadows and darks which form patterns are important in this painting style. For example, an artist might stress the softness of a gray day. Things are painted rather than drawn, and far objects fade off into the distance. The time of day and the kind of day are important to the impressionistic painter.

If you want to paint in this style, try squinting at your subject matter. Be guided by this view and be conscious of how different lighting changes what you see. Don't be

concerned about details. Use big brushes and paint rather than draw.

Claude Monet is just one of the masters of this art style. A study of his work and of other impressionists can help you to understand impressionism.

## Abstract

Abstract painting involves putting aside the way things look and giving emphasis to what the artist considers important. Parts of the subject matter are rearranged, simplified or even omitted. An extreme example would be to paint the color of a flower and leave out its shape and texture.

To begin, choose what you want to use and arrange it in ways that have meaning for you. Use any or all of the elements: line, color, form, value and texture, to create the composition. Rearrange things and parts of things, leave out, and change sizes and proportions. The idea is to organize what is important and share your new view of the subject matter.

With the freedom involved in abstract painting comes a lack of the security of rules along with the responsibility for making choices. But most importantly, the freedom offers space for creativity. As in all art, the main emphasis continues to be the use of the elements of art to achieve a total composition.

A forerunner of abstract painting was Paul Cezanne. He put composition before representation, breaking rules of proportion and perspective to do this. His main concern was the way the viewer's eye traveled about the painting surface. At first glance, his work looks quite representational. However, study will show the beginning of an abstract quality in his paintings and some things he did to achieve his compositions. Despite the representational quality of his work, Cezanne is often called the father of modern art.

Best known among abstract painters is Pablo Picasso. He was a master of many styles, with proven ability as a draftsman and realistic painter. His work has done much to dispel criticism of modern art.

One style much favored by Picasso was cubism. The cubist uses more than one eye view in a single painting. A full front view of two eyes can be painted on a face shown in profile. A bottle or vase can be painted showing the side, top and bottom, all with a full view. What is known becomes more important than what is seen. Often objects are reduced to planes or flat surfaces.

If you want to paint abstractly, begin by deliberately breaking the rules of perspective, deliberately making things look different from the way you see them. Make your goals efforts to create compositions that encourage the viewer's eye to travel in and around the painting. Em-

phasize the essentials of subject matter that you feel are important. Let go. Break the rules and have fun!

## Expressionism

The expressionist painter's main interest is to communicate feelings and emotions. Subject matter and realism take second place. The results are often deep and moving painting statements.

When attempting expressionism, concentrate on the feelings you want to express and use the elements of art to convey them. Colors are chosen to help create moods rather than to show how subject matter looks. Lines, shapes, values and textures are used in similar ways.

Some ways to create moods in painting include the use of blue to suggest coolness, light colors to give a feeling of softness, and bold lines to convey strength. What's important is for the painter to offer his or her own personal interpretation of the elements. By doing this, creative expression is what it should be: honest, personal, deep, open, original and unique. Getting in touch with your feelings is necessary before using paint to project those feelings. You succeed in expressionistic painting to the degree that you satisfy yourself.

An appreciation of expressionism can be gained by studying the work of artists such as Roualt and Chagall. Both are exceptional painters and masters of expressionism.

## Primitive

Primitive painting is difficult for anyone with a working knowledge of perspective. In fact, if you want to be a primitive painter it might be wise just to paint and avoid learning how to draw. Perspective seems to ruin primitive art. Be conscious of what makes good composition and learn how to handle paints and brushes. Forget about perspective and how to draw. Work toward telling a creative story with form and color.

The appeal of primitive painting rests in innocence, story and composition. Grandma Moses is the most popular primitive painter. Her paintings of rural America have an almost universal appeal. Some well-trained professional painters have chosen to paint in the primitive style. Lauren Ford, a professional painter of New England scenes, gave a primitive flavor to some of her works. Primitive painting is a delightful form of art.

## Surrealism

Surrealism is fantasy painted very realistically. Impossible scenes are painted with photographic clarity and detail. It is the stuff that makes up our wildest dreams.

Choose ideas from fairy tales, fantasy, science fiction or your own imagination. The objective is to make the unreal world exist within a painting. Represent the impossible.

Salvadore Dali is the best known of surrealistic paint-ers and probably the most productive. Surrealism, like other art forms, is judged by its composition.

## Non-Objective

Making a non-objective painting consists of making marks, lines, and shapes, blending shading and textures on canvas without representing objects or any recognizable subject. The elements of art form a design composition which stands on its own. The painter strives for good use of the principles of art: unity, variety, balance, rhythm and harmony. Success is found in good composition and in the feeling created by the painting.

Some people find it difficult to accept non-objective art at first. We forget that we appreciate non-objective de-signs in ties, dresses, drapes and wallpaper. We accept non-objective designs in fabrics and other materials. A non-objective painting needs to be appreciated and en-joyed for its design.

It's a challenge to avoid painting objects and subject matter, but the difficulties can become fun. One way to begin is by putting aside your brushes. Work with sponges or a brayer, which is a roller usually used for printing. Both of these will make unusual shapes and de-signs and will make it difficult to represent subject matter. When doing non-objective painting let the painting sort of flow and the fun of the process take hold. The next time

you paint, you can go back and try your luck with brushes.

The styles of art overlap and combine. Each artist, too, approaches styles in his or her own way, adding a creative dimension that is strictly his or her own. Vincent Van Gogh's work is impressionistic but unique because of additional designs, often swirling, made by brush strokes. Some artists work in more than one style. Picasso is noted for his cubistic paintings, but he also painted in many other styles.

The goal of the artist is to find his or her own style. It need not fit into existing classifications. New styles are creative breakthroughs which add to the dimensions of painting. Every painter should seek the way that is his or hers without feeling a need to conform.

# FRAME AND SHOW

**Framing**

A painting never really looks finished until it is framed and hung. The frame and background can help a painting become an eye-catcher or a center of interest. A framed painting should be hung at eye level or where it can be viewed with ease.

The choice of frame is finally a matter of personal taste and judgment. Some things to consider when selecting the frame are where the painting will hang and the effect of a particular frame on the work.

A frame should be selected to enhance the painting. For example: wide frames usually help large paintings, while small paintings need simple frames. Ornate and/or bright colored frames can detract from a painting. The

coloring in a frame should pick up and accent the colors in the painting.

Custom-made frames offer the molding of the artist's choice and provide an exact fit. They're desirable but usually quite expensive. Anyone with carpentry skills and a miter box can make his or her own frames and many painters do this.

A wide variety of ready-made frames are available in art shops and department stores. Some cost a fraction of the price of custom-made frames. Although they usually lack the quality or fit of handmade frames, they can be satisfactory for standard-size paintings.

While framing all one's works can be very expensive, it's important to view each painting in a frame. A solution might be to paint in one or two standard sizes. Keep on hand several frames in your selected sizes for the purpose of viewing and showing your work.

## Showing

Painting is a form of communication and should be shared. Some of the joy goes out of painting if the results are put away and unseen by others. Paintings belong on walls—those of the painter and others. Favorite paintings can be kept, but they should be shared in some way. Other works should be exhibited, given away or sold.

Painting exhibits are very popular. Banks, libraries and other public buildings frequently have short term ex-

hibits as a service to artists and the general public. Painting groups often arrange or sponsor group exhibits as well as shows for a single painter. Exhibits sponsored by church, civic, charitable and other organizations are held in many places, including shopping malls and sidewalks. An artist can participate in many exhibits by simply paying a fee and taking care of his or her own display. Sometimes, shows are juried which means that only paintings approved by a committee are permitted to be shown.

People appreciate the opportunity to look at paintings. Sometimes they buy, more often they look. While paintings on exhibit will sometimes be criticized, more often the public admires, enjoys and appreciates. There is no denying that showing your paintings involves ego risk. But more importantly, showing paintings is a rewarding experience.

# OTHER USES OF ACRYLICS

The delightful feature of acrylic paint is its versatility. Acrylics can be used for most arts and crafts activities. They meet the needs of commercial artists, illustrators, sign painters, and craftsmen. Acrylics work well on a wide variety of surfaces, including wood, shells, metal, glass, cloth, paper and almost any other non-resin or non-oil base surface. When in doubt about a surface, experiment on a small sample of the material.

Acrylics are quite durable and withstand washing, sunlight, heat and cold without damage. They're good for both outdoor and indoor uses. Acrylic varnishes can be applied to add durability, but acrylic paint alone can withstand outdoor conditions for substantial periods of time.

An unusual art work can be produced by doing a collage or montage held down with acrylic gel medium combined with paint. Acrylics can also be used for textile painting, including the decorating of shirts, other clothing, napkins, tablecloths, wall hangings and other fabric items. Shells and stones also can be decorated with acrylics.

Acrylics also work well on glass. Ordinarily, the paint is applied to the reverse side of the glass, which is then backed with material in a contrasting color. For example a delicate, light painting on glass might be backed with a piece of dark or bright colored velvet. Old bottles and jars can also be painted to make decorative vases, lamps and containers. Don't paint containers which might be used for food, as acrylic paint, like most paints, has a poison content.

There are many methods for applying acrylics. Thick impasto effects are possible if you add specially prepared modeling paste to the paint and then apply it with a knife. Thin glazes can be made by adding water or an acrylic medium to the paint. Acrylics can also be used with stencils and stencil brushes, hard rollers called brayers, sponges and toothbrushes. Different shaped objects can be dipped into acrylic paint and used to print designs.

It would be impossible to list all the possibilities for using acrylics. The fact is—the only limit to their use is the unlimited source of creativity within the individual who wants to paint.

# OVERCOMING HANDICAPS

The creative years are often preceded or accompanied by losses of physical ability and stamina. Although physical problems can cause difficulties for the painter, it's possible to compensate.

A person who lacks the strength and energy to paint for long periods of time can still paint effectively with acrylics. The paint dries quickly and there is little or no color change when the paint dries. Acrylics require little preparation, involve a minimal mess, and can be cleaned up quickly.

A studio or section of a room set up as a painting area makes it feasible to leave most materials ready for work. Brushes must always be washed after use and the palette has to be covered with foil and put in the refrigerator to keep the paint from drying. That's all that's necessary. A comfortable chair and a table of the proper height for painting are essential for a studio area.

It's a good idea to step away from a painting while you are working on it to see how it looks from a distance. If getting up is difficult for you, a reducing glass will be helpful. A reducing glass is a lens that reduces rather than magnifies. Without moving, you can view the painting as if from a distance. Reducing glasses are available in some art supply stores and where optical equipment and supplies are sold.

Since painting is a visual art, eyesight is essential. However, there are people who are nearly legally blind, some suffering from cataracts, glaucoma, double vision, or other eye diseases who have become successful painters. This writer paints constantly despite eyes which cannot fuse and have a lack of depth perception. A knowledge of perspective eliminates the depth perception problem. Eye difficulties do not rule out painting. As long as there is some sight ability the painter can work.

The goal of many painters is to paint big and bold with contrasting colors. Poor eyes can see well enough to do such painting. Close, detailed work does not have to be

a part of painting. Some people with eye difficulties find it best to make their initial sketches with paint so they don't strain their eyes with faint pencil marks.

Painters with poor eyesight will find it advisable to shorten their working time. Good lighting is essential. The paints, the surface to be painted and the subject, if one is used, should all be very well lighted.

Numb, stiff or shaky hands do cause problems for some painters and require compensation. People with cerebral palsy have little control over their movements, yet some of them have learned to paint. Working with big brushes helps. It's also helpful to rest the hand and/or arm on something for support while painting. I once taught a junior-high school girl who had cerebral palsy. She couldn't control her hands enough to paint. But she found a way! She held the brush with her teeth.

Detail, straight lines, and hard edges can be a problem but they are not absolutely essential to painting. Even these things can be accomplished with aids. Masking tape can be used to preserve an edge. Once the painted edge is dry, the tape can be removed. Negative stencils, specially made from a page of disposable palette or oak tag, can be used. The negative stencil is made by cutting out the shape to be painted. The stencil showing the outside shape plus additional inside details can be glued down with rubber cement. Open areas can be painted. Once the paint is dry, the stencil can be removed.

Straight lines with a brush can be made by resting the painting on a table edge so the desired line can be parallel to the table edge. By resting the wrist or part of the arm on the table edge, the brush can be extended to the place where the line is to begin. The arm is just moved along the edge with the brush touching the painting until the line is completed.

For an individual who has a creative spark, only a total lack of physical ability can stop him or her from painting. Painting may be more difficult, but finding ways of compensating are possible and definitely worthwhile.

# GLOSSARY

**Abstract:** A painting style concerned with the essence of subjects rather than with visual appearances.

**Acrylics:** A modern polymer paint with a water base.

**American Artist:** An exceptional art magazine that is published monthly.

**Balance:** In painting, balance is a visual feeling of stability and even distribution of the combined elements within a painting.

**Basic Shapes:** Square, rectangle, pyramid, sphere, cylinder. All other shapes seem to stem from or include aspects of one or more of these five shapes.

**Beaverboard:** A fiberboard used in construction that has a suitable painting surface.

**Blending:** The process of mixing paint gradually so that separate colors and/or values move from one to another without a line marking the change.

**Brayer:** A hard rubber roller used to spread printing ink or paint.

**Bristles:** The hairs or synthetic materials used to make the head of a brush.

**Brushes:** Tools with bristles held together with glue and metal and attached to handles of wood or plastic. Painters use two types of brushes: flats and rounds. Flats have bristles arranged in a horizontal shape. Rounds have bristles placed in a circular or round shape.

**Canvas:** Cloth prepared as a painting surface. The cloth is sized, prepared with gesso and stretched over a wooden frame.

**Canvas Pads:** Canvas-like sheets of paper packaged in pads. These sheets are suitable and inexpensive painting surfaces.

**Canvas Panels:** Sturdy cardboard covered with a canvas-like material. These panels are the most frequently used painting surface.

**Canvas Stretchers:** Thin, rectangular pieces of wood made to fit together to form a frame. Canvas is attached to the stretcher frame.

**Charcoal:** Porous carbon used for drawing. It comes in either stick or pencil form.

**Collage:** A two-dimensional artistic composition created by using a variety of materials such as cloth, assorted kinds of paper, wire and yarn.

**Color:** A phenomenon of light, and a delightful element of art.

**Color Wheel:** A chart showing how colors are made and how colors relate to each other.

**Composition:** The arrangement of everything in a painting.

**Creative:** The use of imagination; going beyond what is.

**Criticism:** An opinion. Its value stems from the ability and honesty of the person who offers it. Criticism is often thought of as unfavorable opinion. However, since opinion includes favorable and unfavorable comments, it can have some constructive value.

**Cubism:** A painting style in which objects are flattened, simplified and reduced to geometric shapes. One kind of abstract art.

**Disposable Palette:** A palette-shaped pad of paper palettes. The sheets can be torn off and discarded after use.

**Easel:** A stand made to hold a painting.

**Elements of Art:** Line, shape or form, color, value and texture.

**Expression:** A way of representing.

**Expressionism:** A painting style in which the expression of feelings is the essential goal.

**Eye Level:** What is seen at the level of the eyes. The horizontal line that can be made if a line were drawn from eye to eye. This line is also the location of the horizon line.

**Gesso:** A white paste with size or glue that will adhere to a surface and help paint to adhere.

**Gesture Drawing:** A quick, rough sketch of the human body that attempts to catch the attitude and feeling of the figure's position and action.

**Glaze:** A wash of color applied over a surface to add a transparent effect.

**Ground:** The quality of a painting surface. A surface needs a texture or tooth to hold paint. Gesso makes a good ground.

**Grumbacher:** An art supply company that carries a full line of art materials including Hyplar acrylics.

**Harmony:** The quality of an arrangement that causes all its parts to enhance all other parts.

**Horizon Line:** The line that separates earth from sky. It always appears to be at eye level.

**Hue:** Another word for color.

**Hyplar:** The trade name for Grumbacher's acrylic paint.

**Imagination:** Creative ability to visualize that which is new and different.

**Impasto:** Thick application of paint.

**Impressionism:** A painting style emphasizing the rendering of an impression of what one sees.

**Landscape:** A representation of an inland scene.

**Layout:** A plan for a painting; a layout is done in the form that is most helpful for the individual painter. It can be rough and sketchy or detailed. It can indicate the lights and darks.

**Line:** A point that moves, has length and can be seen. An element of art.

**Liquitex:** The trade name for acrylic paints and mediums offered by Permanent Pigments.

**Masonite:** A trade name for fiberboard used in construction. Masonite has a smooth front surface and a rough back. Both sides are used as painting surfaces. Masonite can be obtained in several thicknesses. However, it is heavier than most painting surfaces.

**Modeling Paste:** An acrylic paste that includes ground marble and is used to create impasto effects and for making raised textures.

**Montage:** A combination of photographs arranged to form an artistic composition.

**Negative Space:** Every shape that is made creates an additional shape or shapes outside of it. These outside shapes are called negative space.

**Non-objective:** A painting style that has no subject matter or representation of objects.

**Oil Paint:** A traditional painting medium consisting of pigment mixed with oils.

**Opaque:** Non-transparent; that which light cannot be seen through.

**Overlapping:** An object totally or partially covering another object. Objects in the foreground or closest often cover objects farther back in distance.

**Painting Knife:** A flat, flexible type of knife used for painting.

**Palette:** A rectangular or oval shaped, smooth, waterproof surface used for holding and mixing paint.

**Parallel Perspective:** Perspective that deals with how parallel lines seem to slant as they go back in distance.

**Permanent Pigments Inc.:** An art supply company offering a line of acrylics under the name Liquitex.

**Perspective:** The process of representing the way things appear to the eye.

**Pigment:** The colored matter used in making paint.

**Portrait:** A visual representation of a person's face.

**Primary Colors:** Red, yellow and blue. These are the three basic colors from which other colors are made.

**Primitive Art:** A painting style that is simple and innocent, often without the use of skilled technique. Primitive art also refers to the art of primitive people.

**Principles of Art:** Rhythm, harmony, balance, unity and variety. The qualities that make art when combined.

**Realism:** A painting style in which subject matter is presented as realistically as possible in a photographic way.

**Reducing Glass:** An optical glass that reduces rather than magnifies. The glass makes it possible to view a painting as from a distance without physically moving away from the painting.

**Rhythm:** A quality of movement in a painting like the beat in music. This sense of movement is created by the arrangement of the elements of art.

**Seascape:** A representation of the sea.

**Secondary Colors:** The three colors that result when two primary colors are mixed. Orange is a secondary color made from red and yellow. Green is a secondary color made from blue and yellow. Purple is a secondary color made from red and blue.

**Shade:** A color made darker by adding black.

**Shape:** The space that is enclosed when a line meets itself. An element of art.

**Sketching:** Drawing and sometimes shading and/or painting with pen, pencil, brush or other tool. The nature of a sketch is usually rough and quick or unfinished.

**Still Life:** A representation of objects that are mostly inanimate.

**Stretched Canvas:** Canvas stretched on a wood frame to be a painting surface. An excellent, traditional painting surface. It is an expensive painting surface and not necessary.

**Surrealism:** A painting style in which fantasy and the impossible are treated realistically.

**Texture:** The quality of a surface that can be felt and/or seen. An element of art.

**Tint:** A color made lighter by adding white.

**Three-Dimensional:** An object or area with width, length

and depth. Also, a two-dimensional composition that creates the effect of width, length and depth.

**Transparent:** That which can be seen through. A watercolor or wash effect achieved when using acrylics by adding water or gel medium to the paint.

**Two-Dimensional:** A surface to work on that offers only length and width. Also, composition that creates effects limited to length and width. Everything seems flat.

**Unity:** A principle of art referring to the need for wholeness or oneness in a work of art.

**Value:** The amount of lightness or darkness in a color. One of the elements of art.

**Vanishing Point:** A point that is always on the horizon line where receding parallel lines seem to meet if extended.

**Variety:** The principle of art stressing the need for interest created by differences or variation.

**Varnish:** A liquid used to cover a surface to preserve or to add a gloss. It is usually transparent. Acrylic varnish should be used with acrylic paint.

**Visual Art:** Painting and other forms of art appreciated visually.

**Wash:** A thin layer of paint often used to produce an underpainting guide for values or to produce a glazed

effect. A wash usually produces a transparent color. When using acrylics, mix a small amount of paint with water to make a wash.

**Watercolors:** Pigment mixed with water, producing a transparent, water soluble paint.